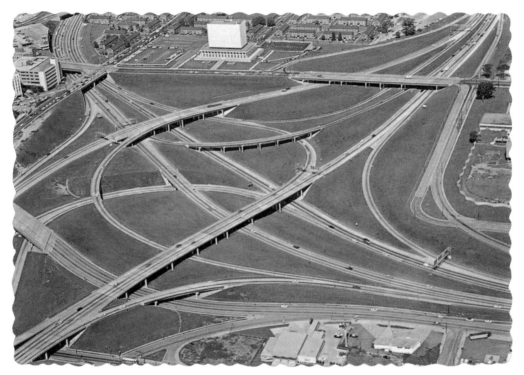

Atlanta, Georgia. Aerial view of the massive interchange complex of Federal Highways I-75, I-85, and I-20.

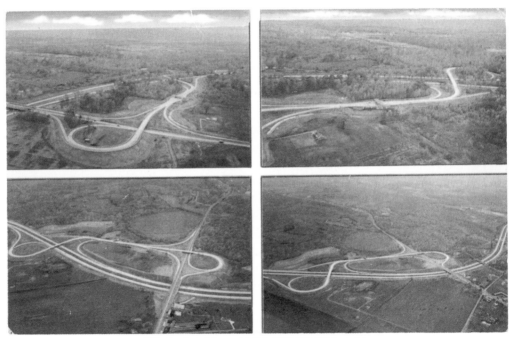

OTP-14—Aerial Views of Ohio's $326,000,000 Turnpike.

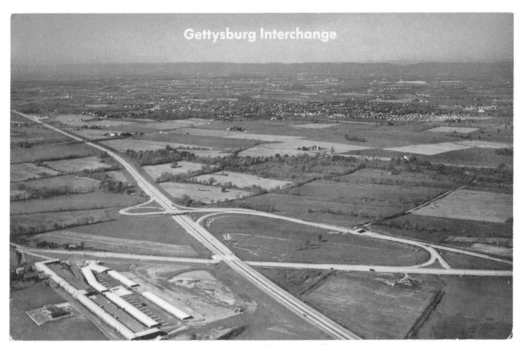

Gettysburg Interchange, Pennsylvania Turnpike.

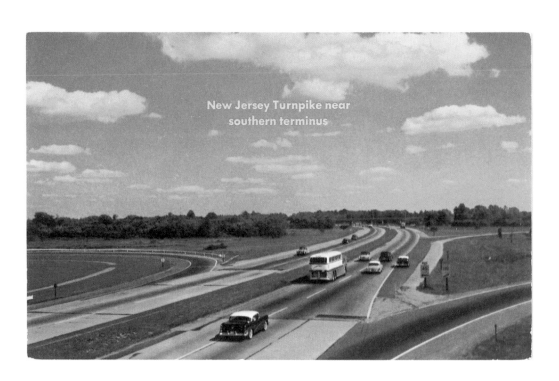

New Jersey Turnpike near
southern terminus

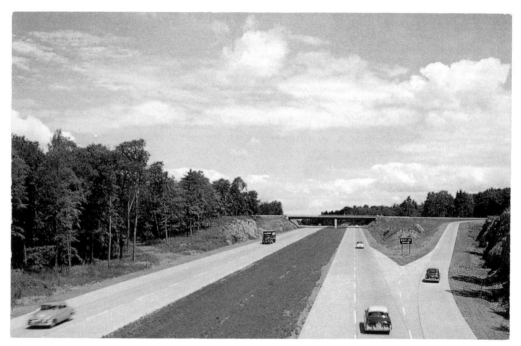

New York State Thruway showing Exit 21, Catskill, N.Y.

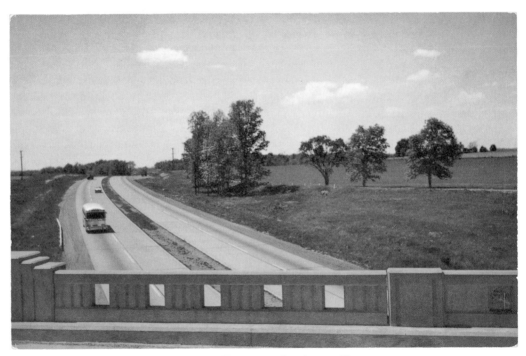

Pennsylvania Turnpike near Downingtown, PA.

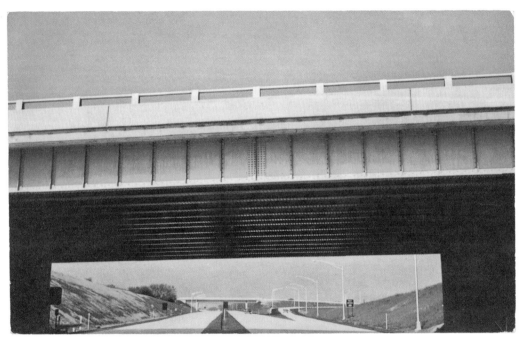

Pennsylvania Turnpike near the Philadelphia Interchange.

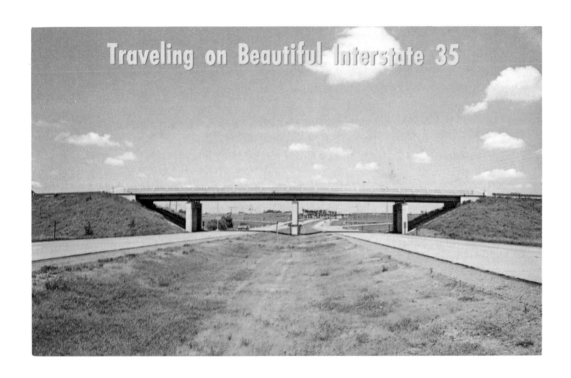

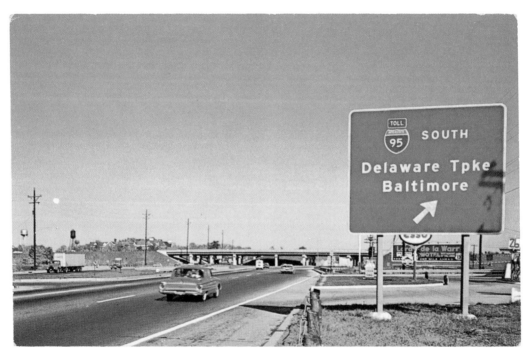

Wilmington, Delaware. The entrance to Rte. 95, the new John F. Kennedy Memorial Highway.

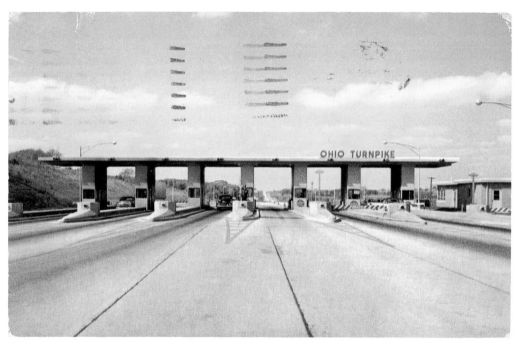

OTP-1—One of the gateways to Ohio's $326,000,000 Turnpike.

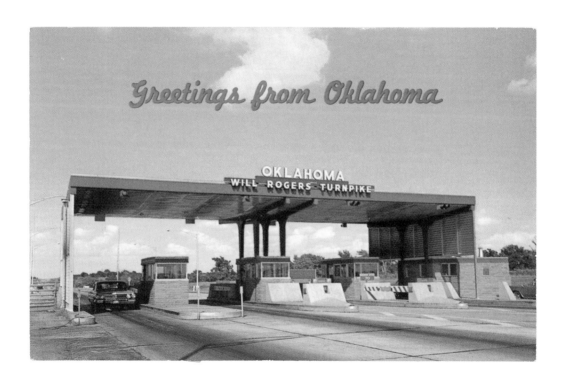

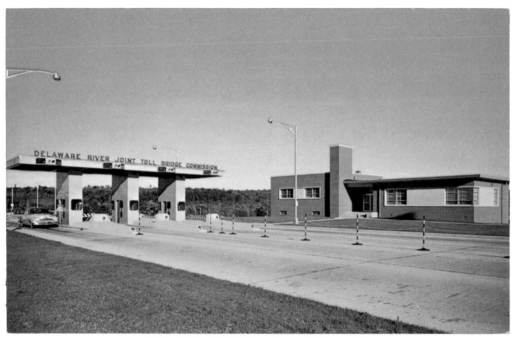

Portland-Columbia Toll Bridge Plaza on US Route 611.

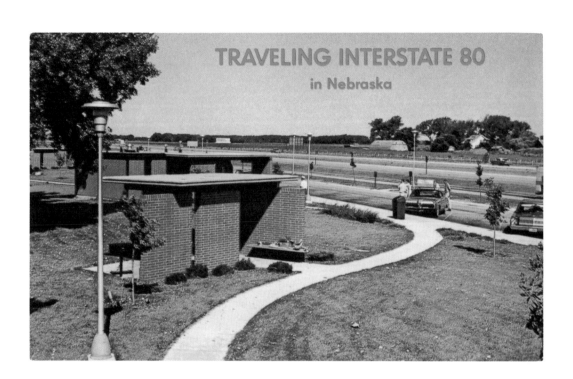

TRAVELING INTERSTATE 80
in Nebraska

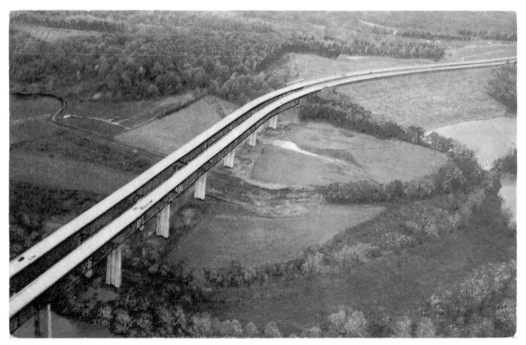

OTP-10—Aerial view of the twin bridges spanning the Cuyahoga River Valley and the Ohio Canal.

PICTURESQUE INDIANA

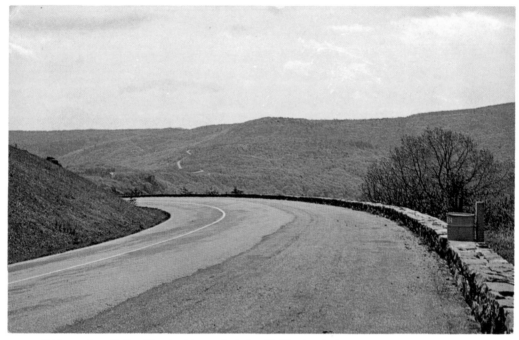

Driving south on Skyline Drive about three miles before Big Meadows Lodge entrance, Front Royal, Virginia.

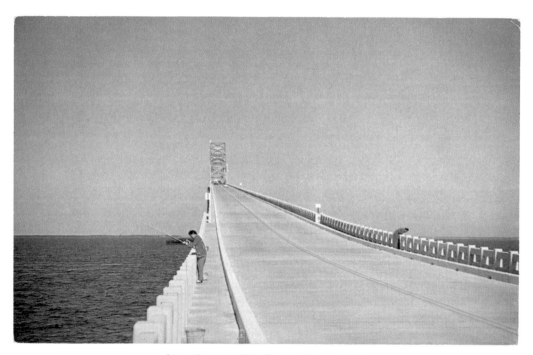

Approach to span of the Sunshine Skyway, Florida.

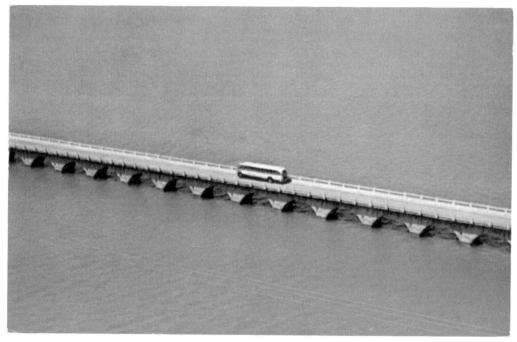

Greyhound bus on the Seven-mile Bridge, overseas highway to Key West, Florida.

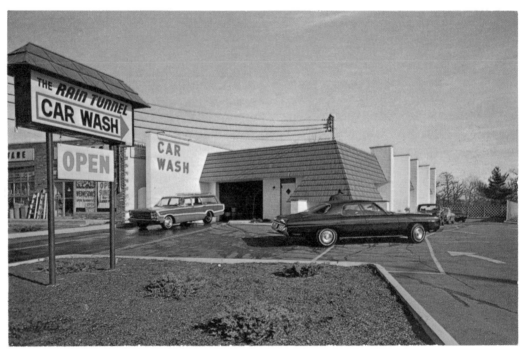

The Rain Tunnel, North Babylon, Long Island, N.Y.

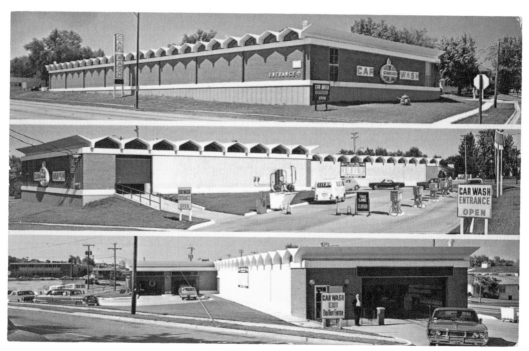

Custom Car Wash, Overland Park, Kans.

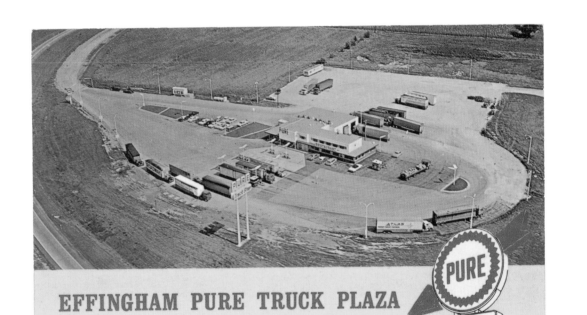

EFFINGHAM PURE TRUCK PLAZA

Interstate-70 and 57 at Fayette Avenue
Effingham, Illinois

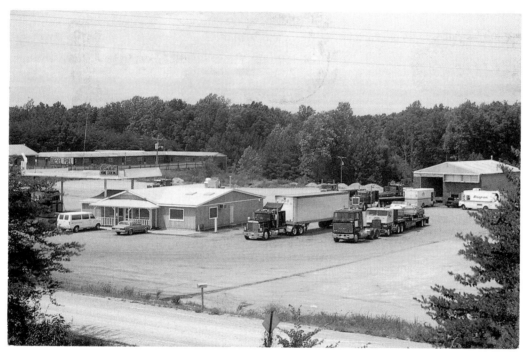

I-40-96 Truck Stop, Exit 182 off I-40 Fairview, TN.

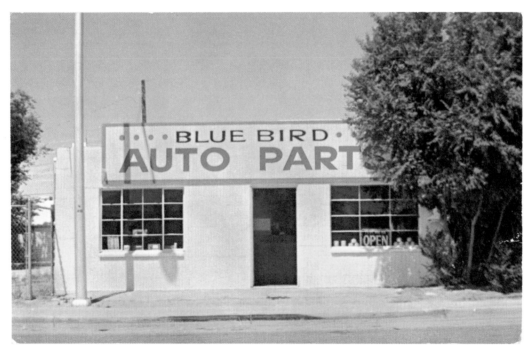

Blue Bird Auto Parts, Las Vegas, Nevada.

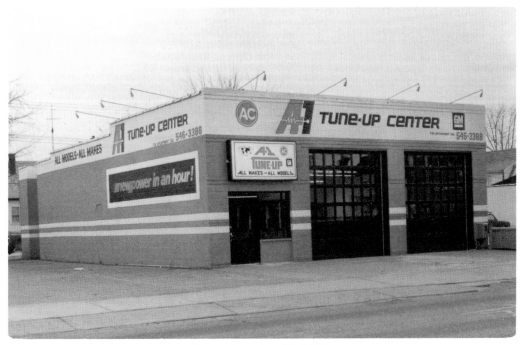

A-1 Tune-up Center, Hazel Park, Michigan.

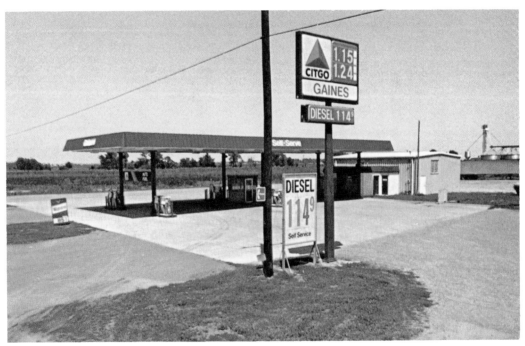

Gaines Truck Stop, Highway 61, Boyle, Mississippi.

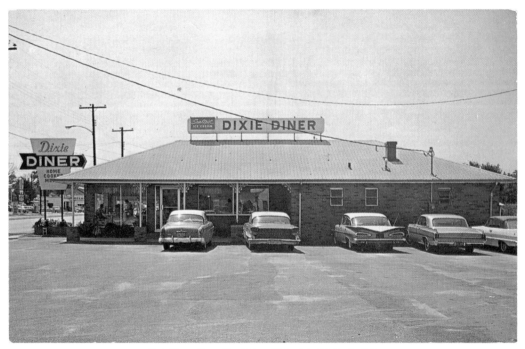

Dixie Diner, Hwys. No. 301 and Interstate 95, Kenly, N.C.

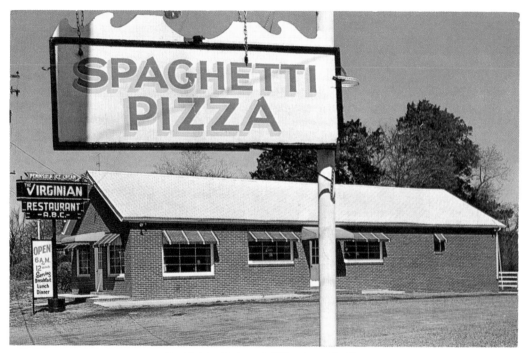

The Virginian Restaurant, Williamsburg, Virginia.

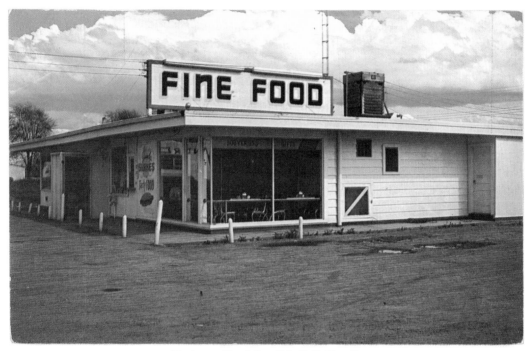

The famous Blue Grill on U.S. 40, St. Elmo, Ill.

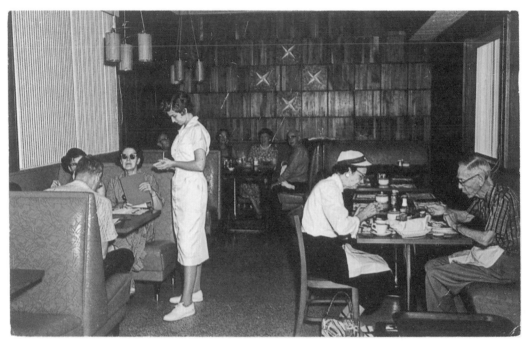

The Walnut Room Bucks Restaurant, one fourth mile thru Tunnel on U.S. 70-74 East, Asheville, North Carolina.

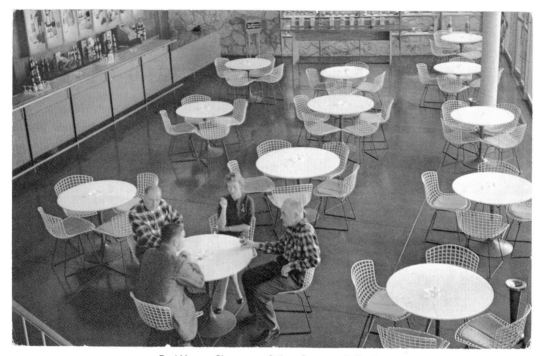

Paul Masson Champagne Cellars, Saratoga, California.

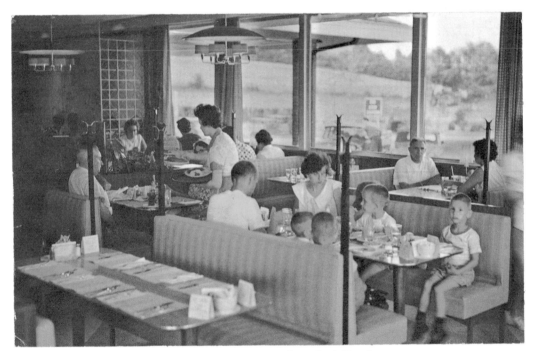

Howard Johnson's Dining Room, Pennsylvania Turnpike.

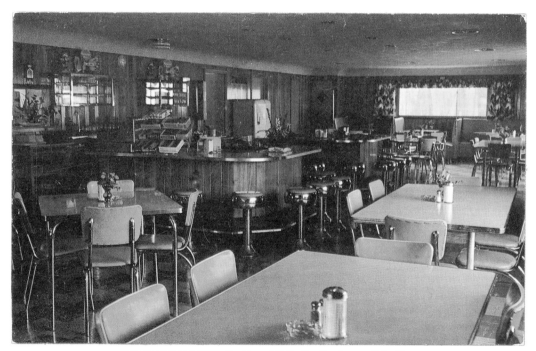

Edgewood Cafe & Motel, On Hiway #52, 7 miles So. Cannon Falls, Minn.

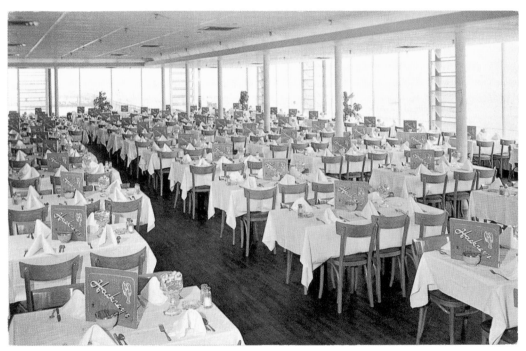

Boardwalk Room at Hackney's, Maine Avenue, Atlantic City, N.J.

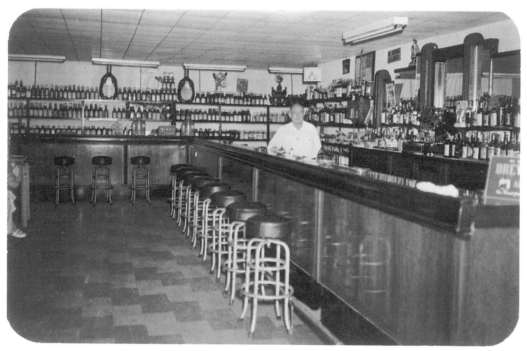

Huss' Liquors, 14 min. south of Wauchula on Road 17, Fla.

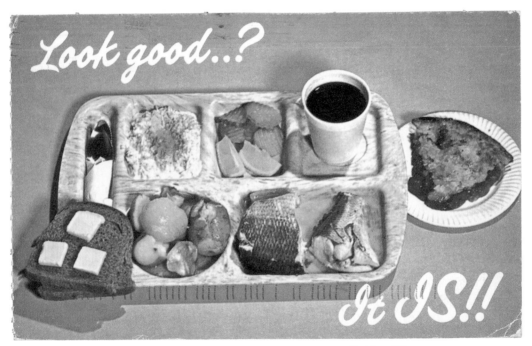

The Famous Mariners' Restaurant Fishboil, Hwy 44 near Fort Bay, Ohio.

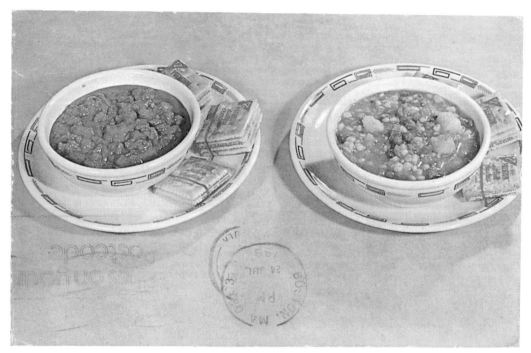

Thorton's Truckstop Diner, Beaumont, Texas.

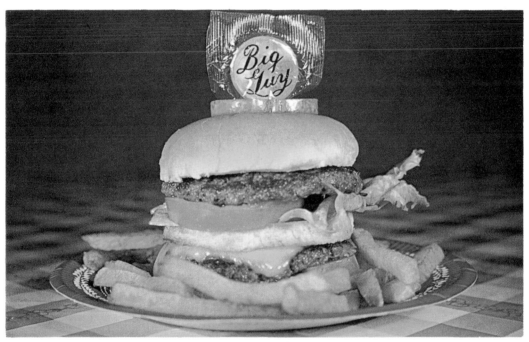

Big Guy Pop 'n Top Sandwich.

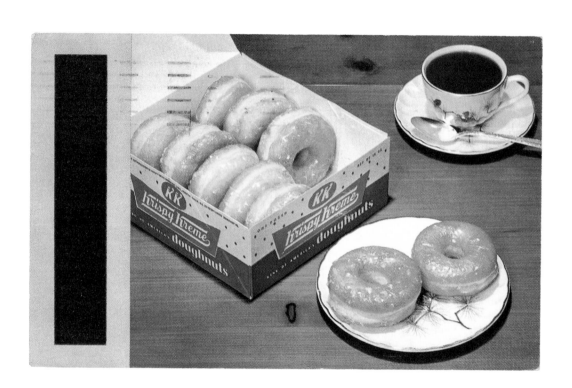

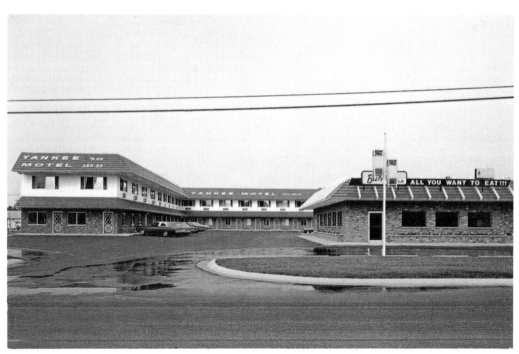

Big Yank Motel and Restaurant, US-131, Kalkaska, Mich.

Partial view of Beachley's 15 unit Auto Court, Barneveld, N.Y.

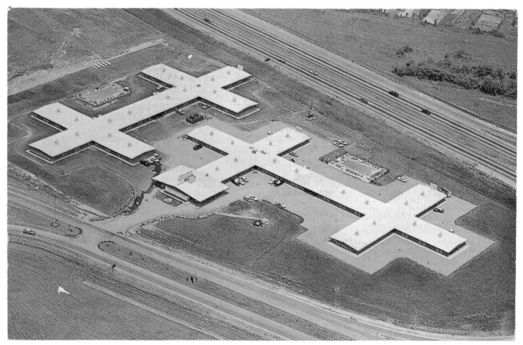

Standiford Executive Inn Motor Hotel, Louisville, Kentucky.

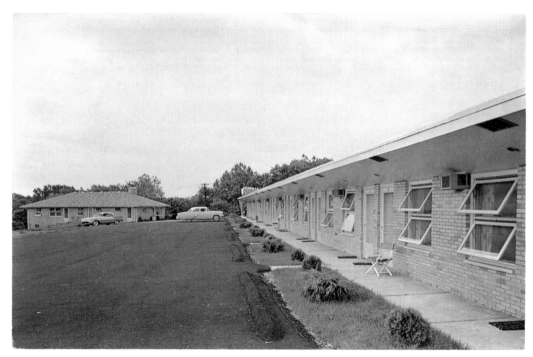

Pike View Motel, Strongsville, Ohio.

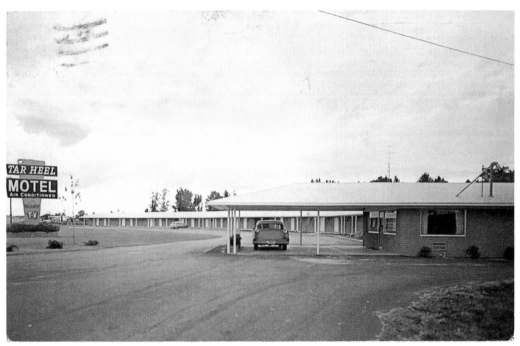

Tar Heel Motel, Clinton, N.C.

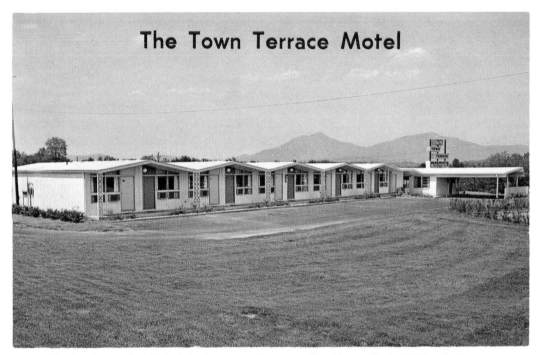

The Town Terrace Motel, Centrally located between Roanoke and Lynchburg on Route 460 West, Bedford, Va.

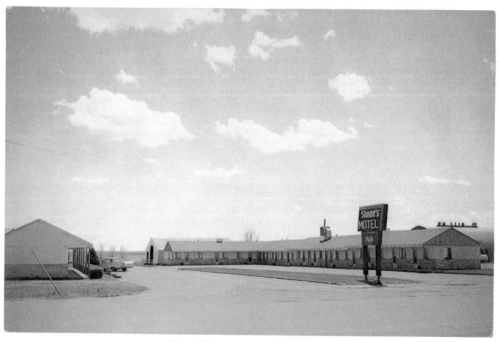

Sloan's Motel, Burlington, Colorado.

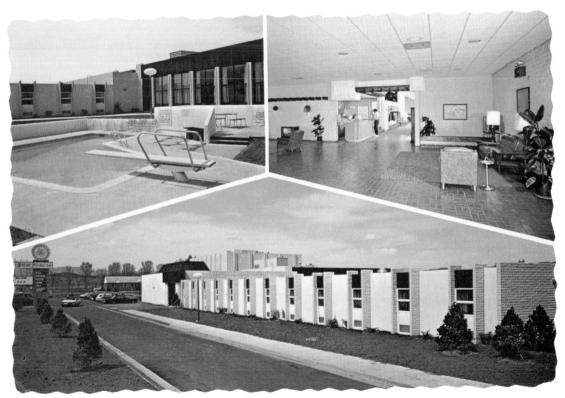

Pino Nuche Pa-ra-sa', On Colorado Highway 172, Ignacio, Colorado.

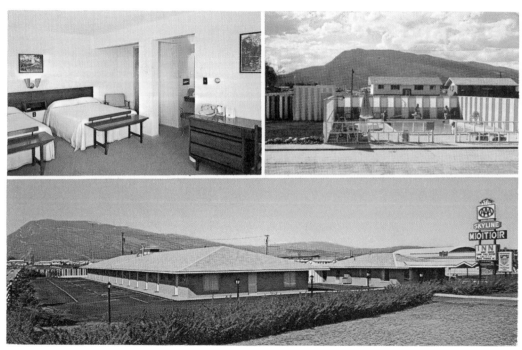

Skyline Motor Inn, U.S. 20, Cody, Wyoming.

Ocean Mist Motor Lodge, Off Route 28 at Sea View Avenue, Cape Cod, Mass.

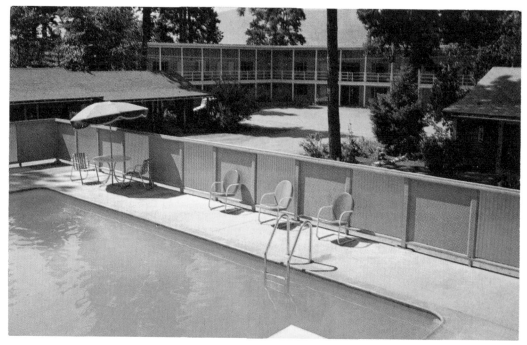

Mountain Air Motel & Ski House, South Highway 99, Mount Shasta, Calif.

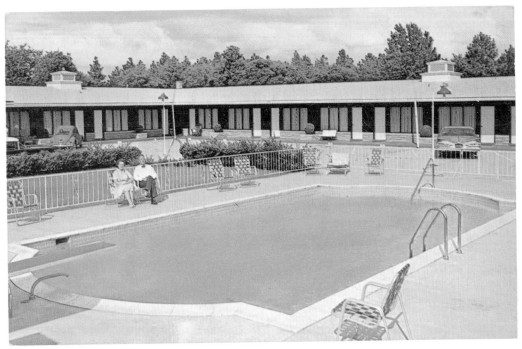

Driftwood Motor Lodge, Fayettesville, N.C.

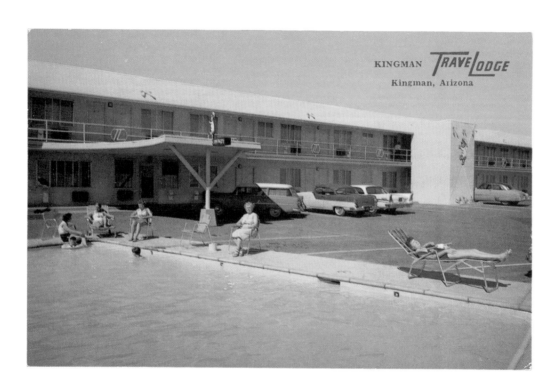

KINGMAN TRAVELODGE

Kingman, Arizona

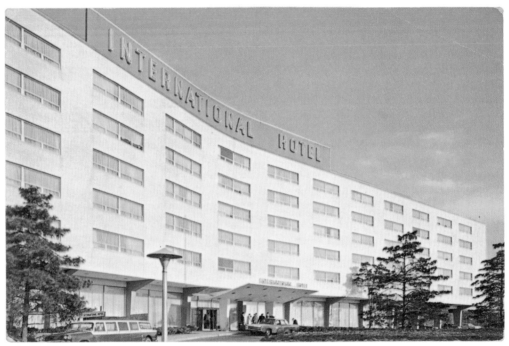

International Hotel, On John F. Kennedy International Airport, New York, N.Y.

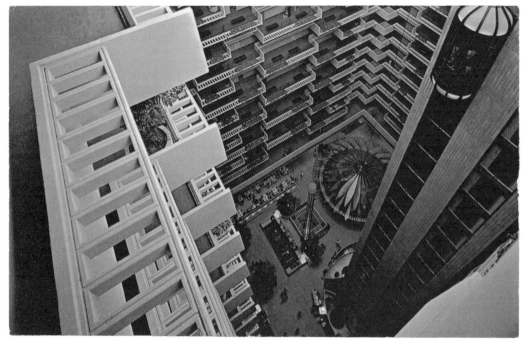

America's most talked about hotel, the Regency Hyatt House, Atlanta, Georgia.

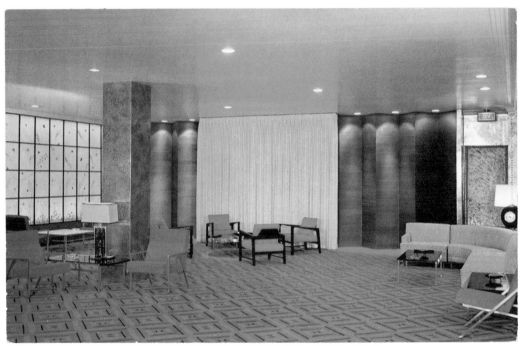

Hamilton Hotel, Chicago, Ill. Where every guest receives a Red Carpet Welcome.

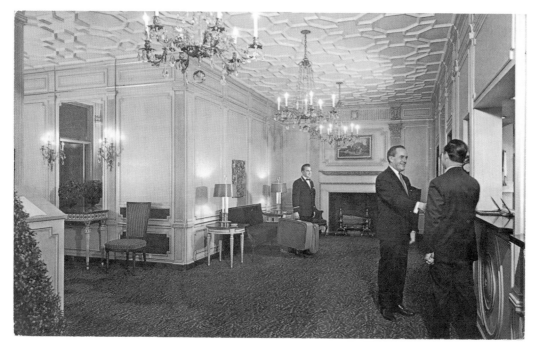

Hotel Salisbury, New York, N.Y.

Linoaks Motel, Alameda, Calif.

Nelva Courts and Restaurant, One mile east of U.S. 45, Meridian, Mississippi.

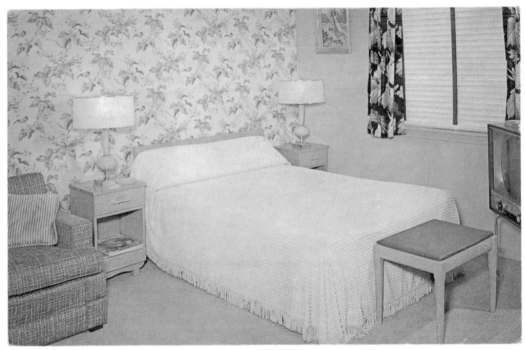

Friendly Motel, Located on Route 104, 5 miles west of Rochester, N.Y.

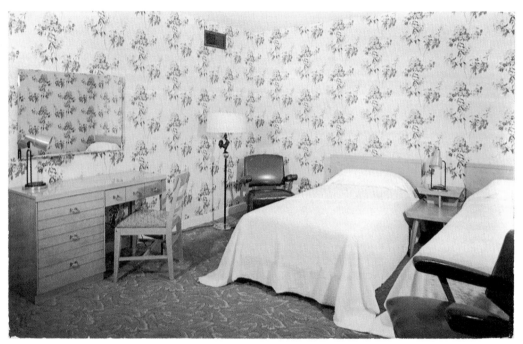

Thunderbird Motel, U.S. Highway 301, Bel Alton, Maryland.

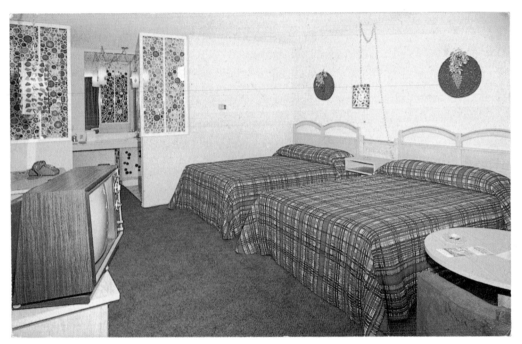

Space bubble dividers, new styrene lighting, daring new interior colors. Cosmic Age Lodge, Anaheim, California.

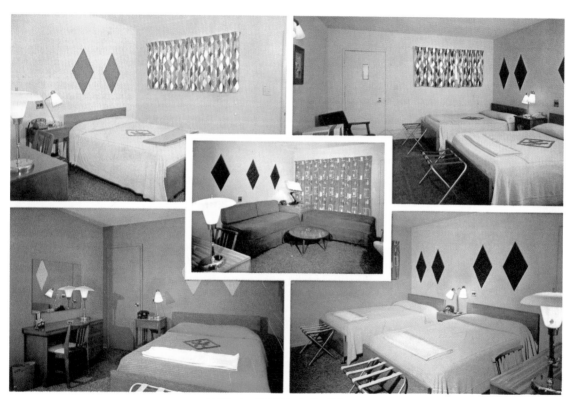

Holiday Inn Hotel, Huntsville, Alabama.

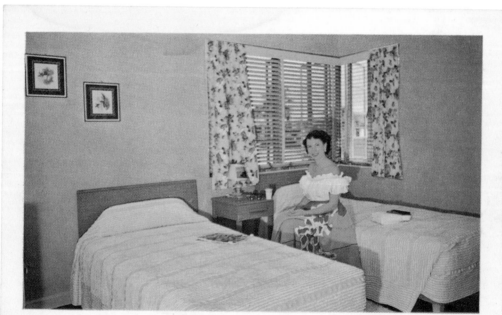

A bright and cheery bedroom at Ellinor Village, Ormond Beach, Florida.

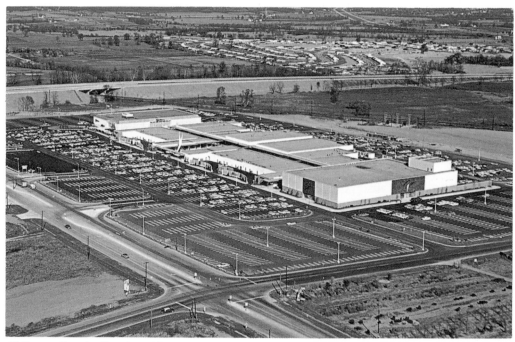

Tri-County—Shopping Showplace of Ohio. Interstate Route 275 at Princeton Pike and Kemper Road in suburban Cincinnati.

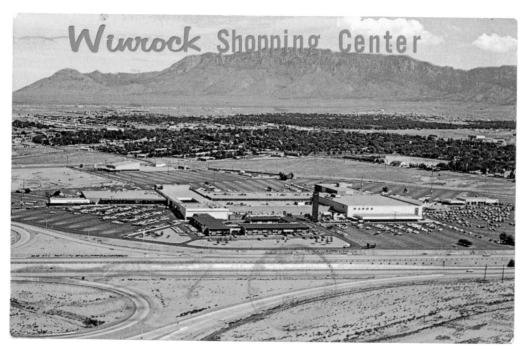

Albuquerque, New Mexico.

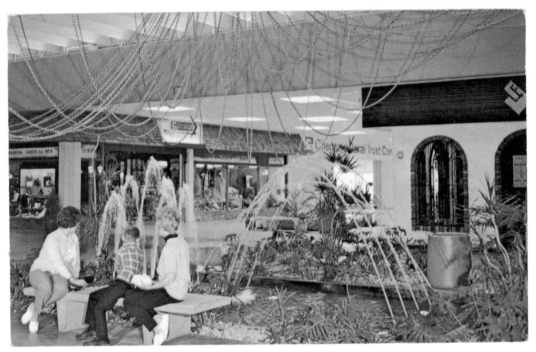

The Mall, Horseheads, New York.

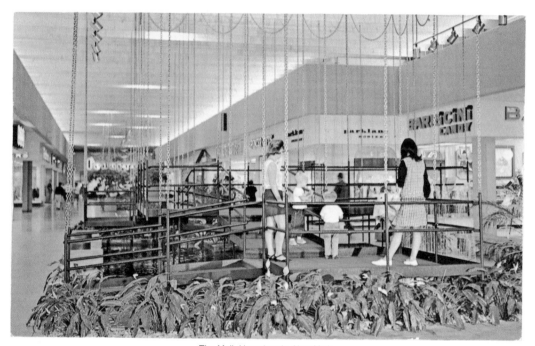

The Mall, Horseheads, New York.

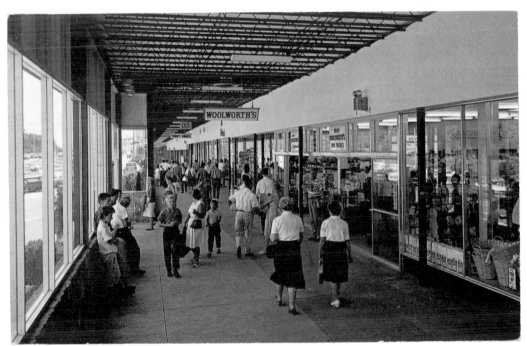

Northway Mall Shopping Center, Pittsburgh, PA.

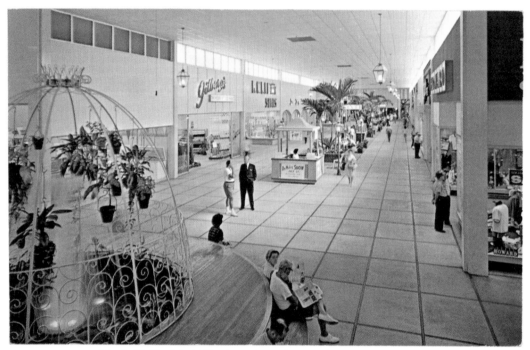

Orlando, Florida. Colonial Plaza's new Million Dollar Air Conditioned Shopping Mall.

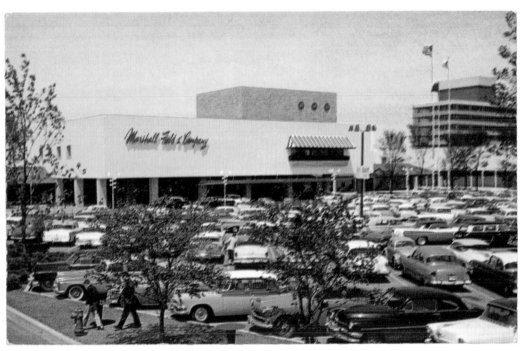

Fabulous Old Orchard Shopping Center, Skokie, Illinois.

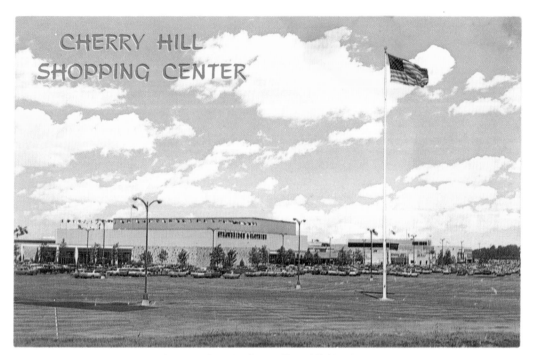

Cherry Hill Shopping Center, Cherry Hill, New Jersey.

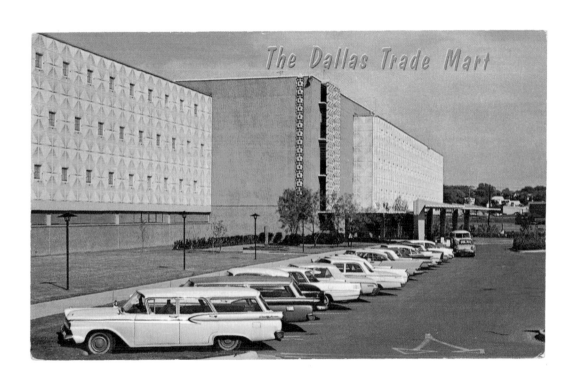
The Dallas Trade Mart

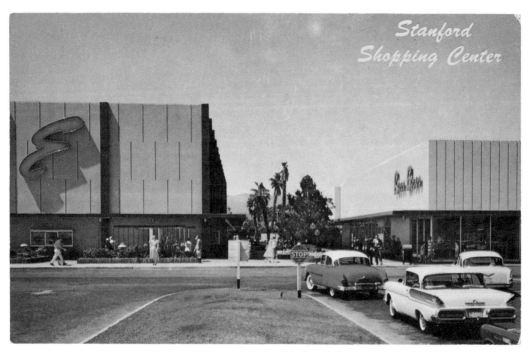

Stanford Shopping Center, Palo Alto, California.

Houston, Texas.

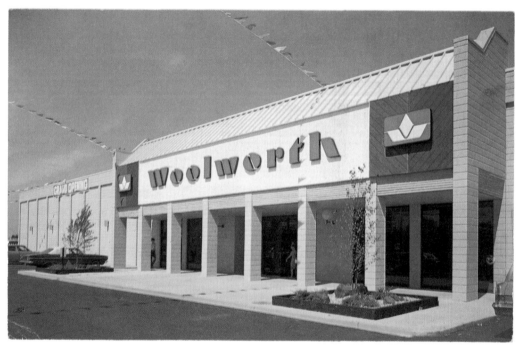

Woolworth new department store, Mesabi Mall—Hibbing, Minnesota.

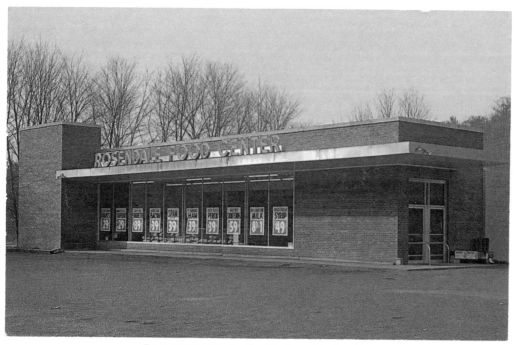

Rosendale Food Center, Rte. 32—Rosendale, New York.

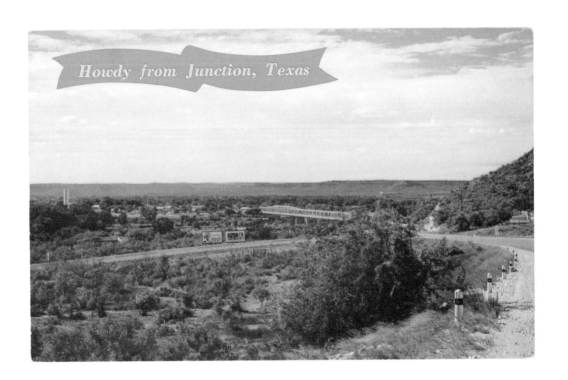

Howdy from Junction, Texas

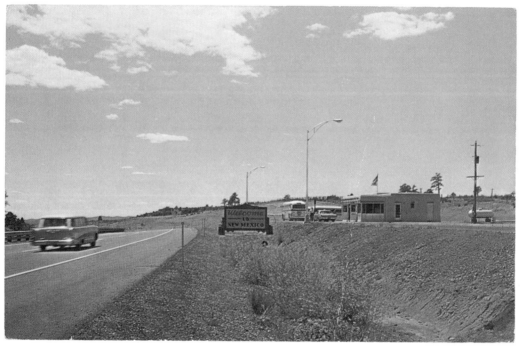

Top of Raton Pass, elevation 8,500 feet. Raton, New Mexico. Gateway to the West.

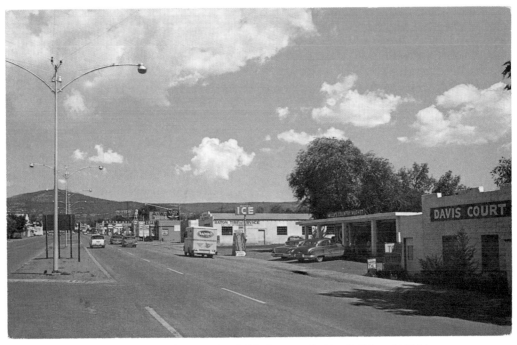

Raton, New Mexico. Gateway to Land of Enchantment. Looking North from 87-85-64.

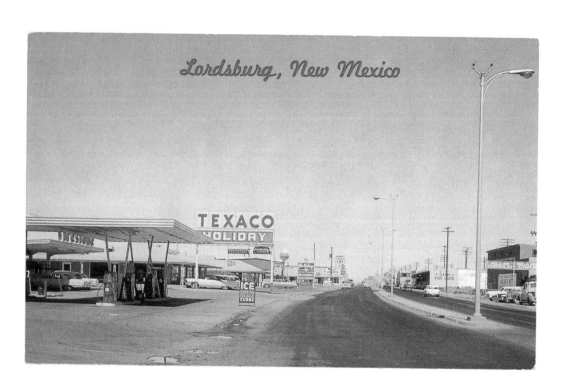

Lordsburg, New Mexico

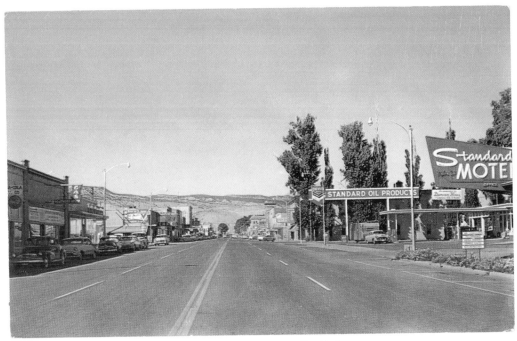

Richfield, Utah. Main Street looking North.

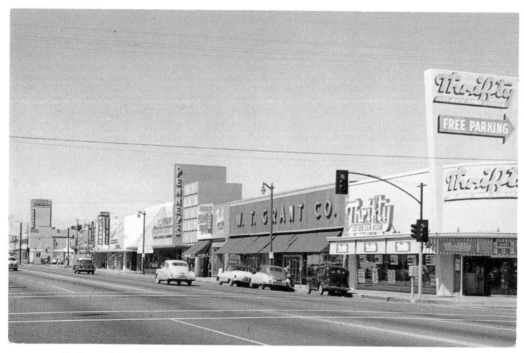

Bellflower, California—Looking North on Bellflower Blvd. from center of downtown business district.

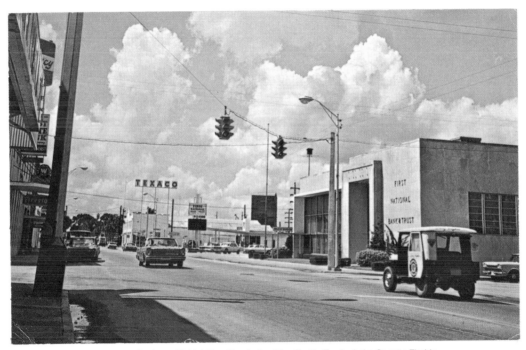

Downtown Business District, Bay Street—Looking South. Eustis, Lake County, Florida.

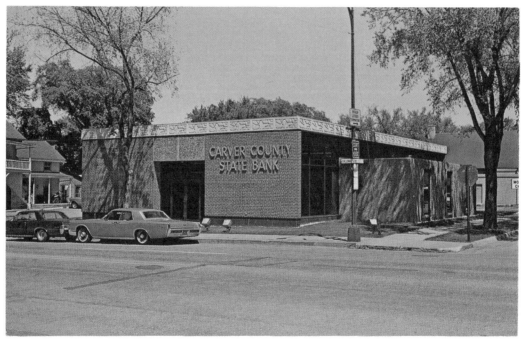

Carver County State Bank, Chaska, Minnesota.

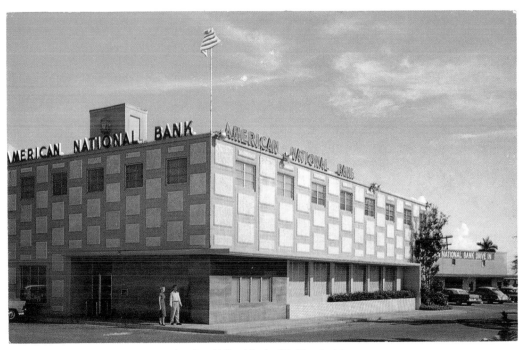

American National Bank of Fort Lauderdale.

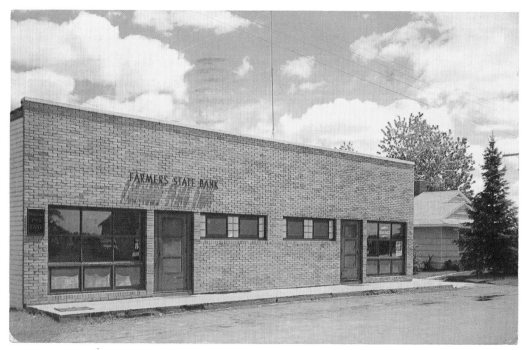

Farmers State Bank of Dorset, Minnesota.

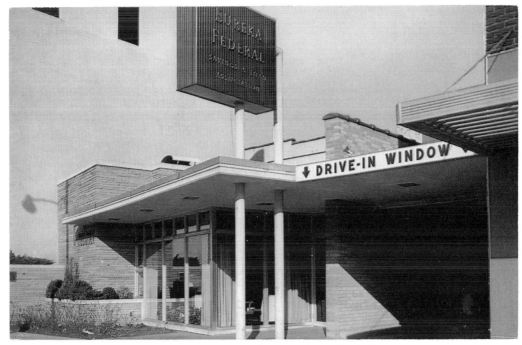

Office Building of Eureka Federal Savings and Loan, Eureka, Kansas.

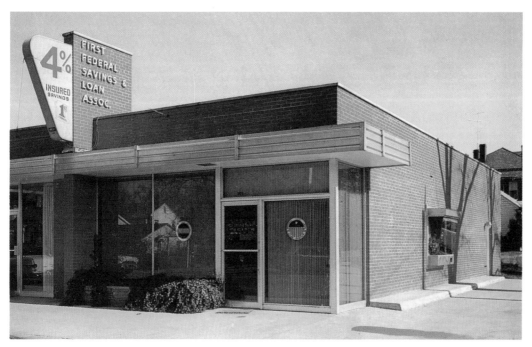

First Federal Savings and Loan Asso., Dunn, North Carolina.

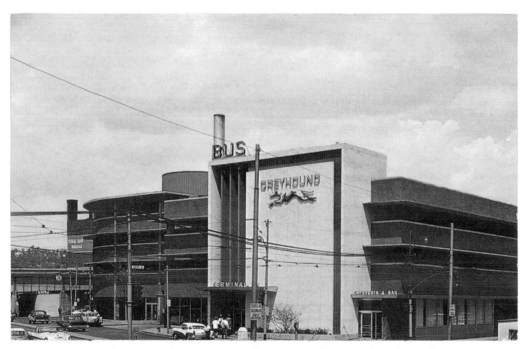

Pittsburgh, PA. The beautiful new and modern Greyhound Bus Station and Ramp Parking Garage.

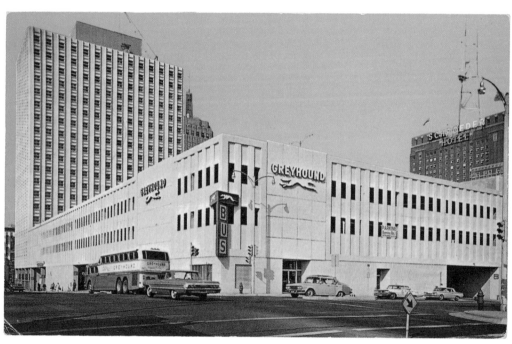

The new Greyhound Bus depot, Milwaukee, Wisconsin.

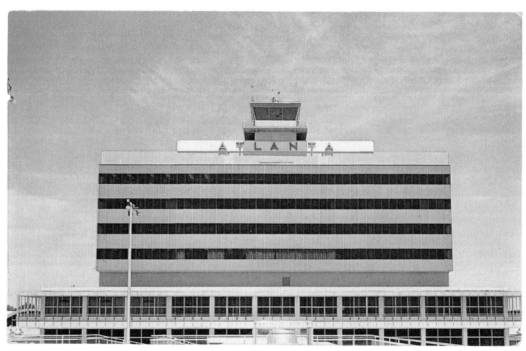

Atlanta Airport's magnificent new terminal building.

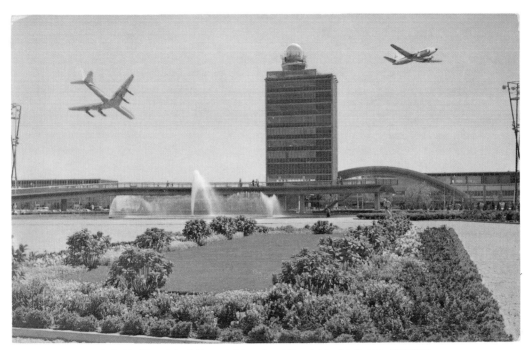

Arrival building, John F. Kennedy International Airport, Idlewild, Queens, New York.

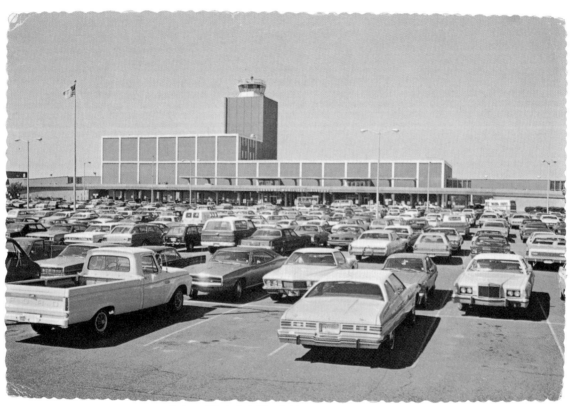

Jackson, Mississippi, Allen C. Thompson Municipal Airport.

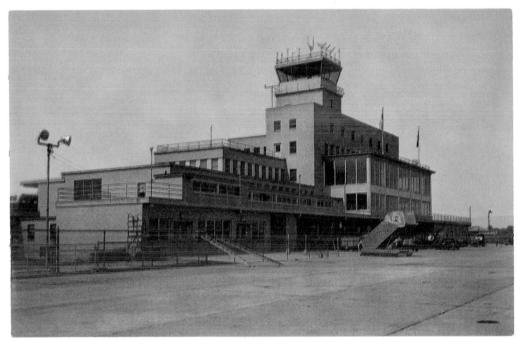

Bradley Field, Windsor Locks, Conn., Hartford's airport.

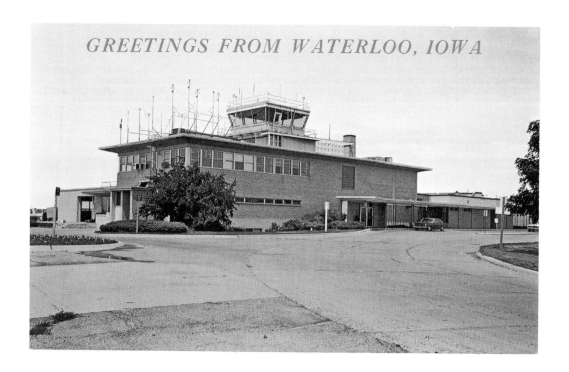

GREETINGS FROM WATERLOO, IOWA

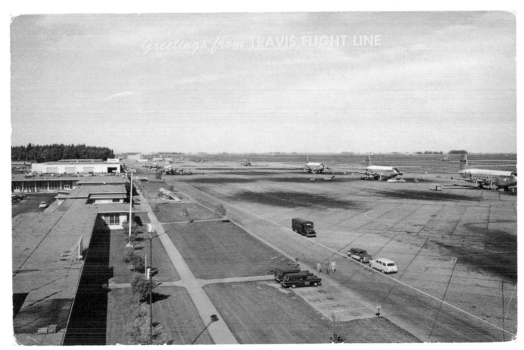

Travis Air Force Base, California.

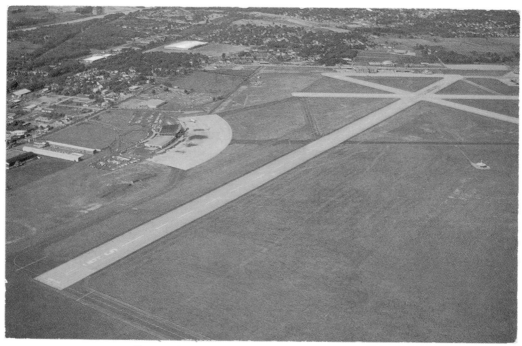

Theodore Francis Green State Airport, Warwick, Rhode Island.

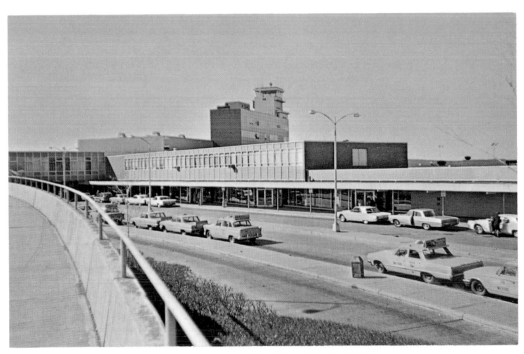

Cleveland Hopkins International Airport, Cleveland, Ohio.

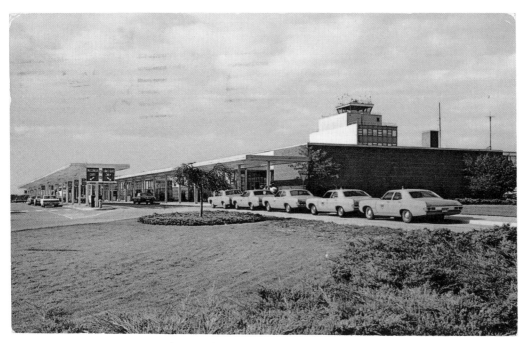

James M. Cox Municipal Airport, Dayton, Ohio.

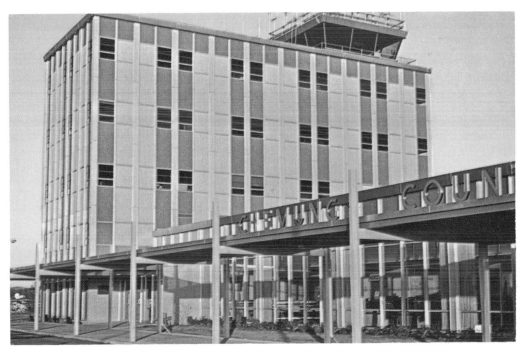

New administration building and tower of the Chemung County Airport at Big Flats, New York.

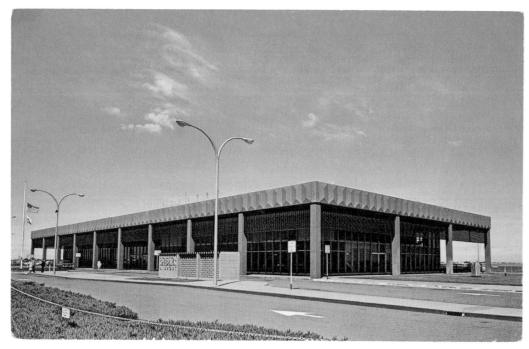

Stockton Municipal Airport, Stockton, California.

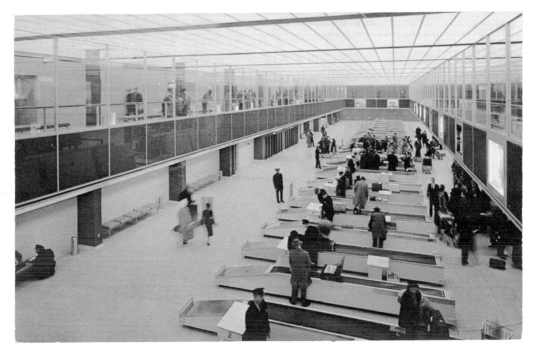

Streamlined Customs Facilities, New York International Airport.

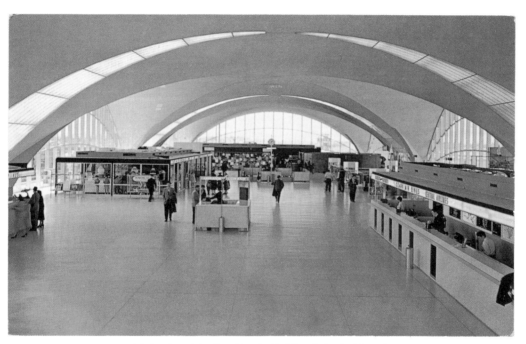

Interior view of the Airport terminal building, St. Louis, Missouri.

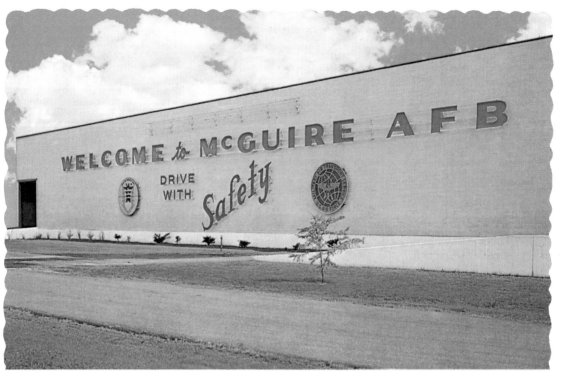

WELCOME to McGUIRE AFB

DRIVE
WITH *Safety*

McGuire A. F. B. New Jersey

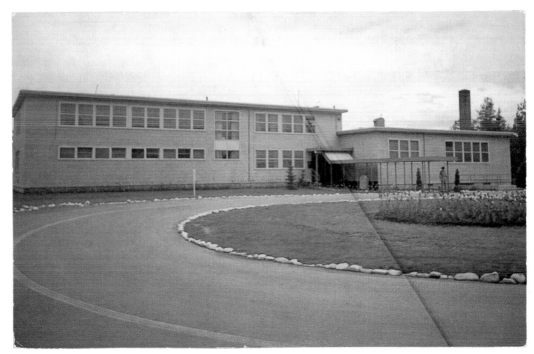

Officers Club, Loring Air Force Base, Limestone, Maine.

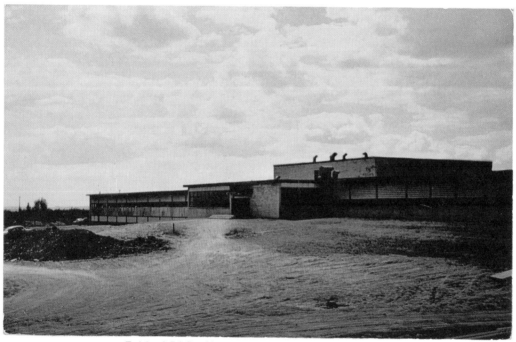
Training & Briefing, Limestone Air Force Base, Limestone, Maine.

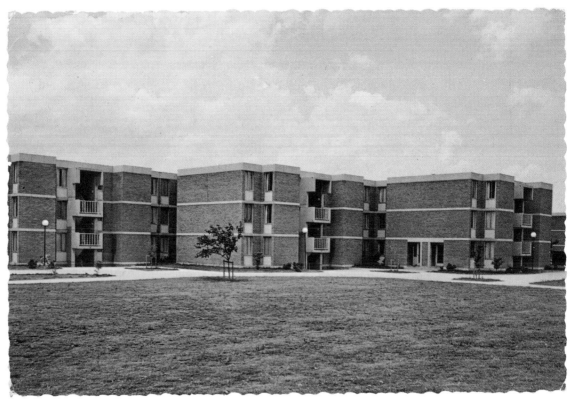

Modern Barracks for a Modern Army, Fort Hood, Texas.

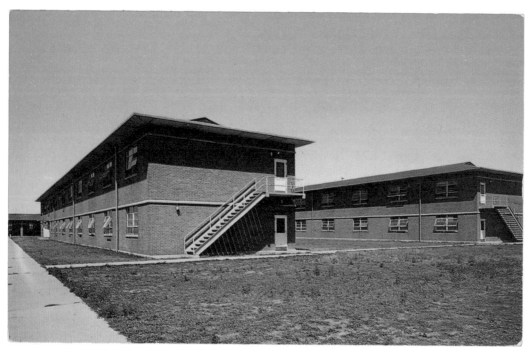

Enlisted Men's Barracks at the U.S. Naval Air Station, Floyd Bennett Field, Brooklyn, N.Y.

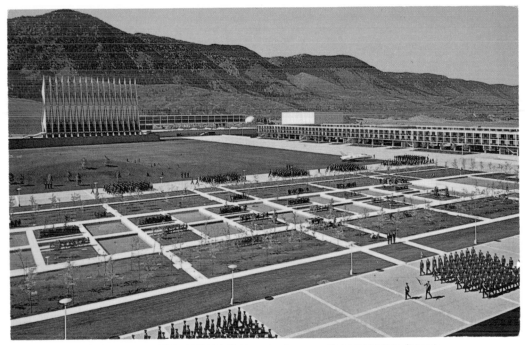

Cadets on way to Dining Hall, U.S. Air Force Academy near Colorado Springs, Colorado.

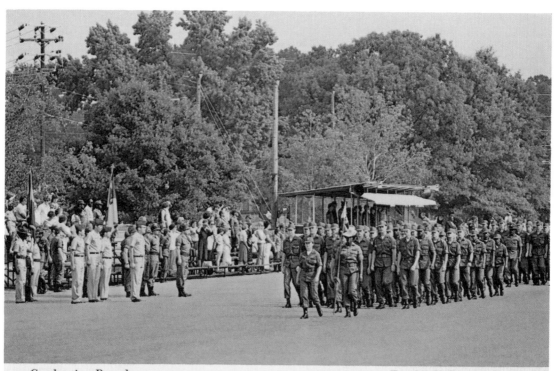

Graduation Parade *Fort McClellan, Alabama*

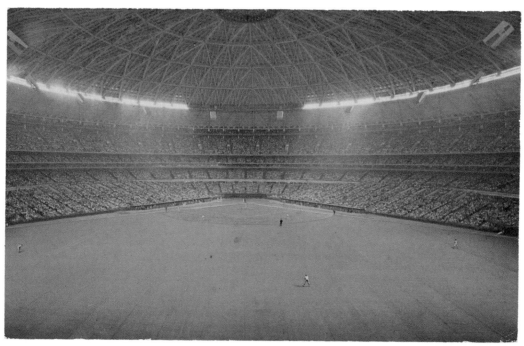

The Astrodome, Houston, Texas.

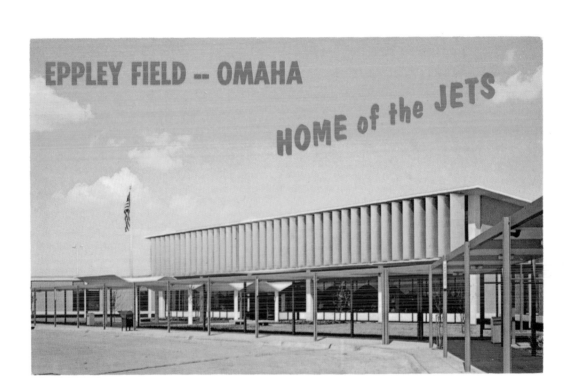
EPPLEY FIELD -- OMAHA

HOME of the JETS

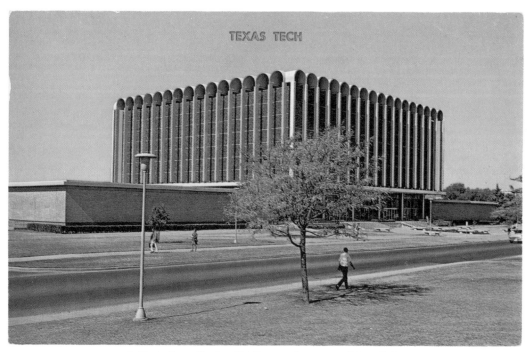

Lubbock, Texas. The beautiful library on the campus of Texas Tech.

Student Union and Girls' Dormitories, State University of New York Teachers College, Oswego, N.Y.

Pratt Institute, Brooklyn 5, New York. Women's Residence Hall.

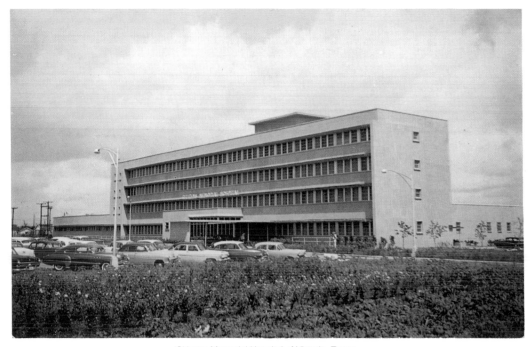

Citizens Memorial Hospital of Victoria, Texas.

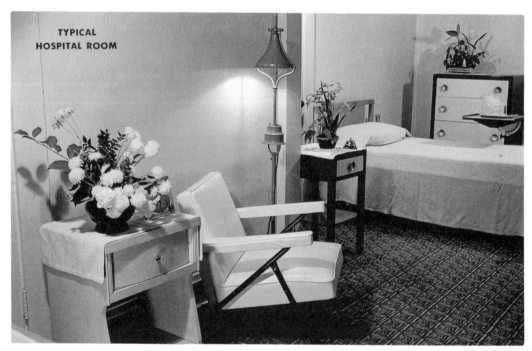

TYPICAL
HOSPITAL ROOM

McMillen Sanitarium Private Geriatric Hospital, Columbus, Ohio.

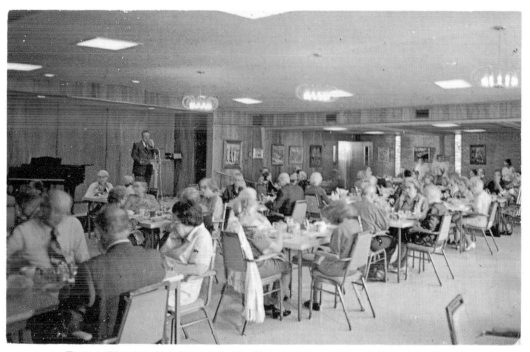

The beautiful and spacious dining room of the Wesleyan Retirement Home in Georgetown, Texas.

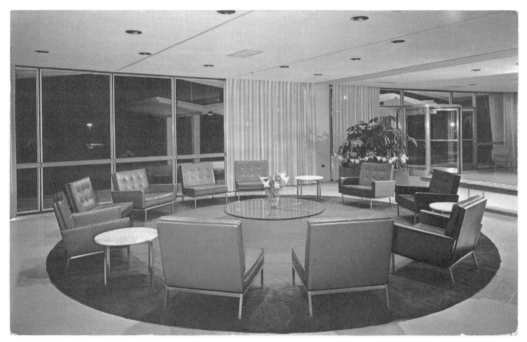

The colorful rug near the entrance of the national offices of the American Baptist churches, Valley Forge Interchange, PA.

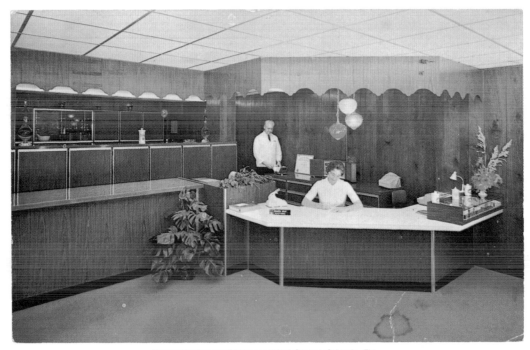

Mount Apothecary Pharmaceutical Center, Orlando, Fla.

The Southern New England Telephone Company's Attended Service Center, Submarine Base, New London, Connecticut.

North Carolina is the nation's largest producer of cigarettes and the R. J. Reynolds Plant is the largest in the world.

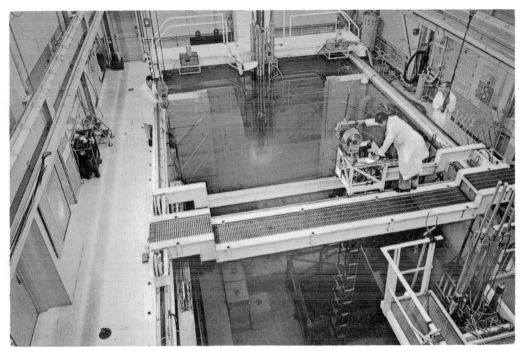

Bulk Shielding Reactor (Top). Pool Critical Assembly (Lower right corner). Oak Ridge National Laboratory, TN.

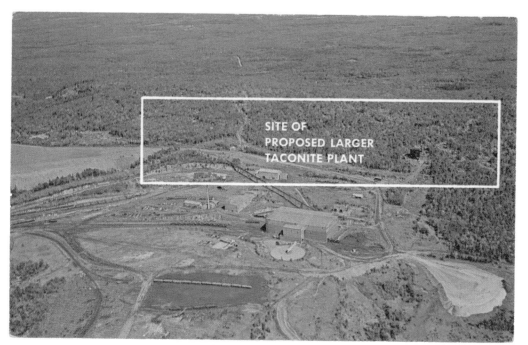

SITE OF
PROPOSED LARGER
TACONITE PLANT

Grand Rapids, Minnesota.

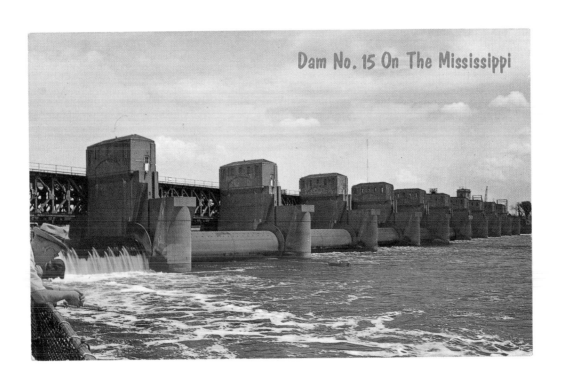

Dam No. 15 On The Mississippi

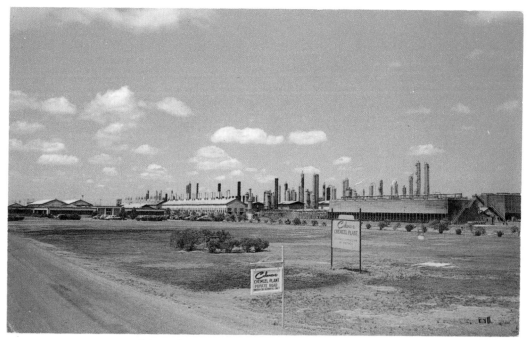

Celanese Plant, located between Kingsville and Bishop, Texas.

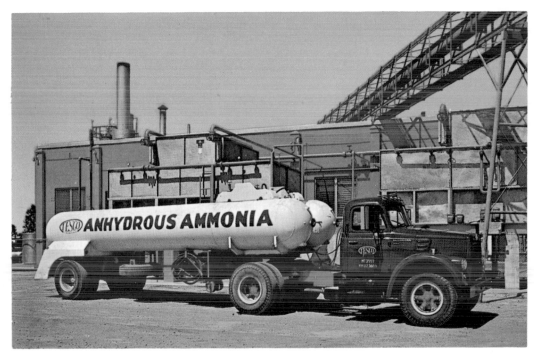

Tesco refrigeration chemicals plant, Tampa, Fla.

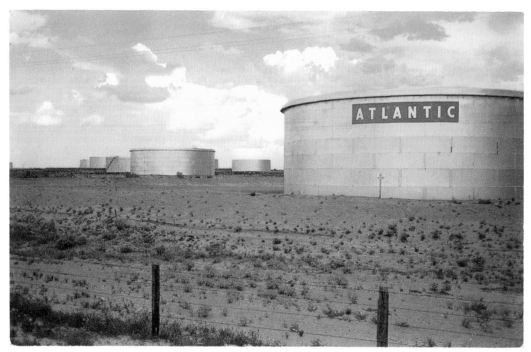

Oil Tank Farm, near Midland, Texas.

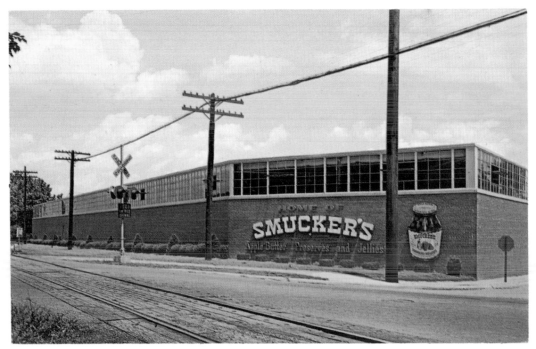

The J. M. Smucker Co. Plant, Orrville, Ohio.

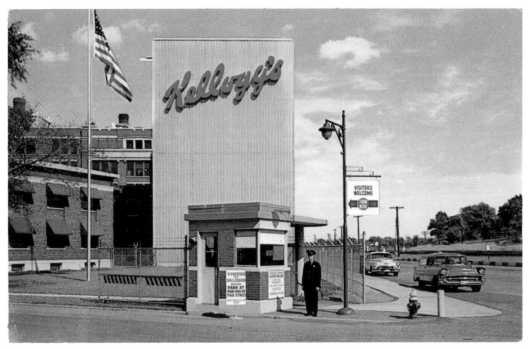

Kellogg's, Battle Creek, Michigan.

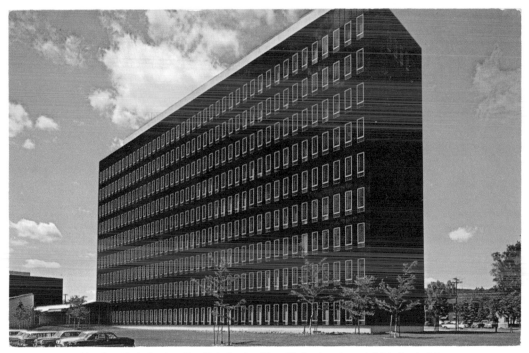

Houghton Park, Corning, New York. Corning Glass Works nine story administration building.

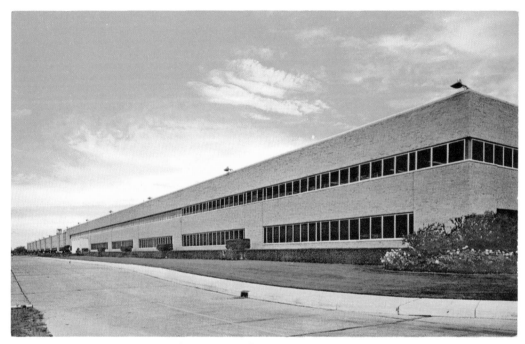

Oldsmobile Plant Three, Lansing, Michigan.

Penta Treated Timber Construction. Enameled, Ribbed Roofing and Siding. Erected For $4350 On Your Location.

The Heart of any Resilient Plastering Job: Olsen REZ Clips

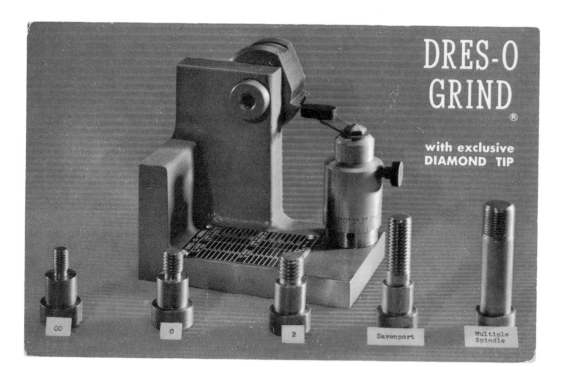

DRES-O
GRIND ®

with exclusive
DIAMOND TIP

OO O 2 Davenport Multiple Spindle

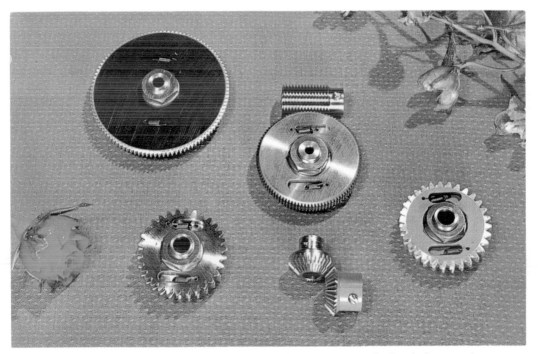

PIC features a complete line of spring-loaded, anti-backlash spur gears, worm wheels and miter-gear sets.

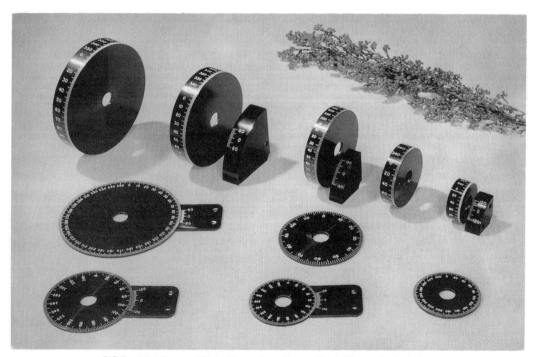

PIC Precision Engraved Dials. Disc or Drum Types—Single-Stop or Vernier Index.

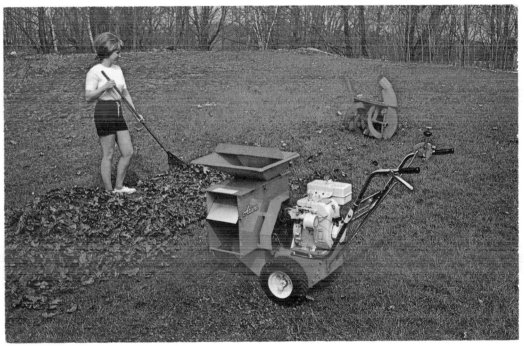

Ariens Sno-Thro—Rotary Mower, Reel Mower, Lawn Vacuum, Rotary Broom, and new Shredder Grinder and Shredder Bagger.

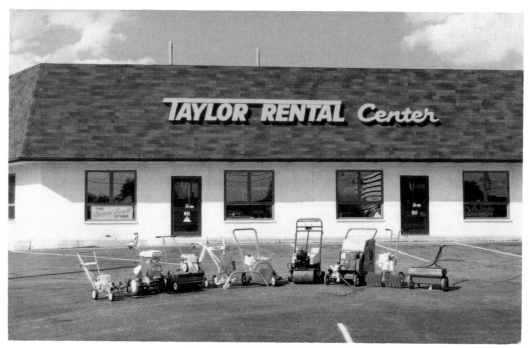

Taylor Rental Center, Mount Laurel, N.J.

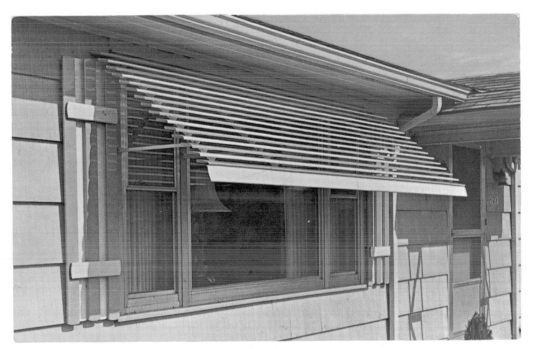

Flexalum Aluminium Awnings.

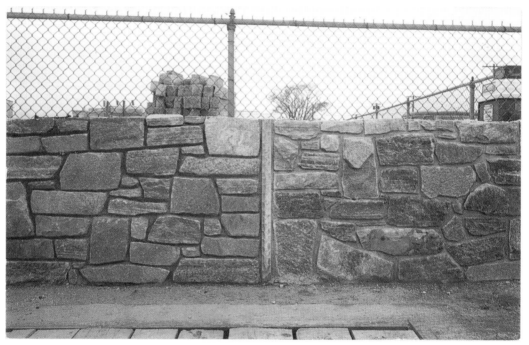

This is a natural blend of stone set to a pattern of random irregular bond. Lawler Stone, Inc., West Hempstead, N.Y

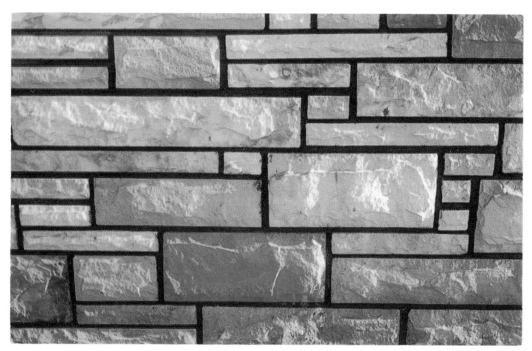

This is French Lick Sandstone. French Lick Sandstone Co., Inc., French Lick, Indiana.

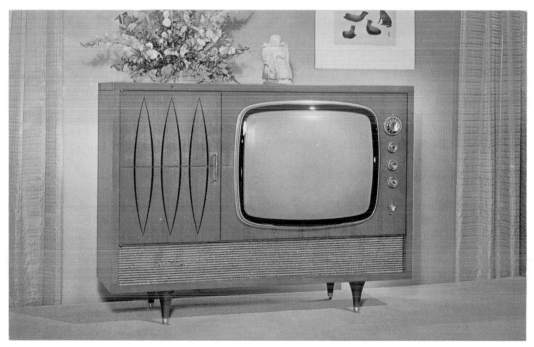

The Sparton 3-way Imperial (#23K4C).

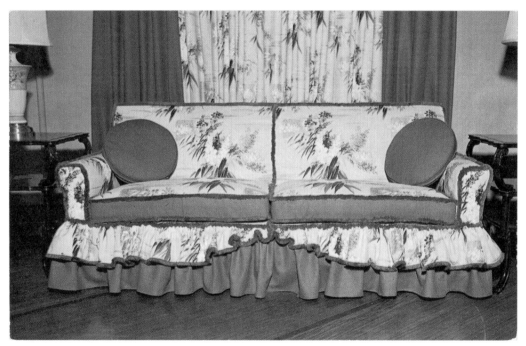

Dover Upholstering Co., Dover, N.J.

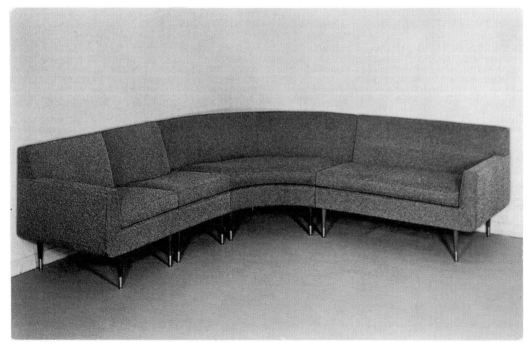

A new sectional group, to match our R-61 chair and R-63 sofa. Stanley Manufacturing Company, Fort Worth, Texas.

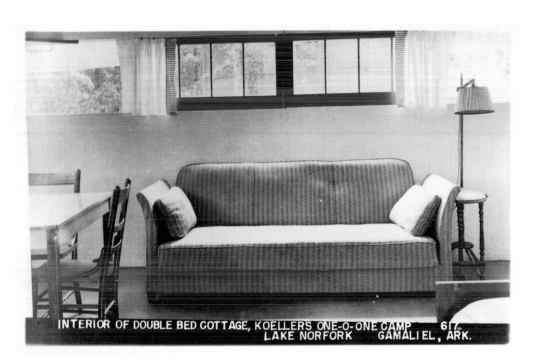

INTERIOR OF DOUBLE BED COTTAGE, KOELLERS ONE-O-ONE CAMP 617.
LAKE NORFORK GAMALIEL, ARK.

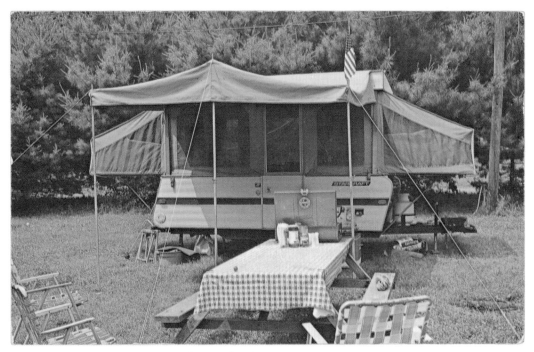

Greetings from Catskill Mountains, N.Y.

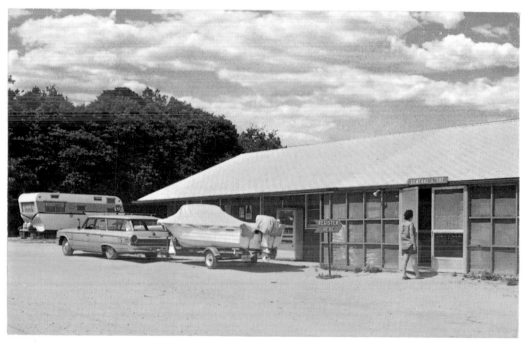

Office and General Store Building, Ocean View Campground, Ocean View, N.J.

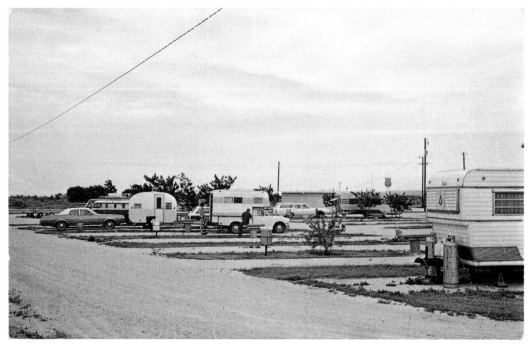

Sunset Travel Trailer Park, Route 1, Fort Stockton, Texas.

Crosswinds TRAILER COURT ● ST. PETERSBURG FLORIDA

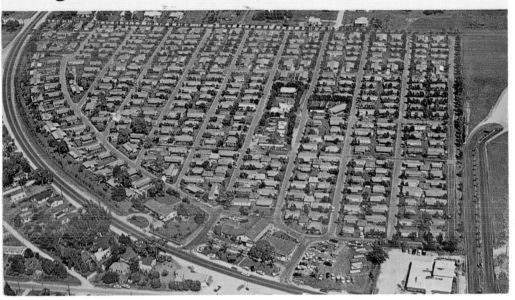

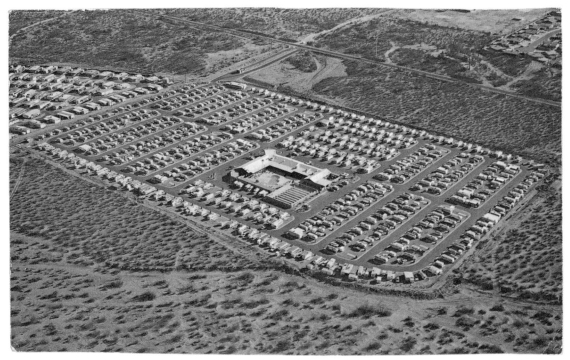

Far Horizons Trailer Village, Tucson, Arizona.

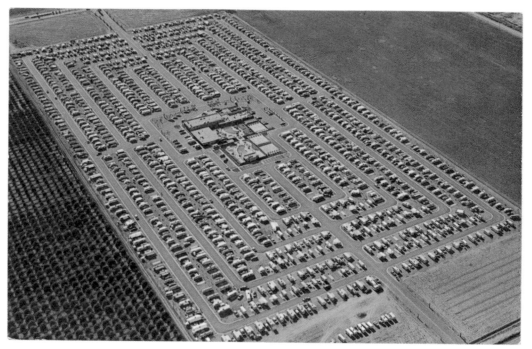
Deluxe Travel Trailer Resort, Mesa, Arizona.

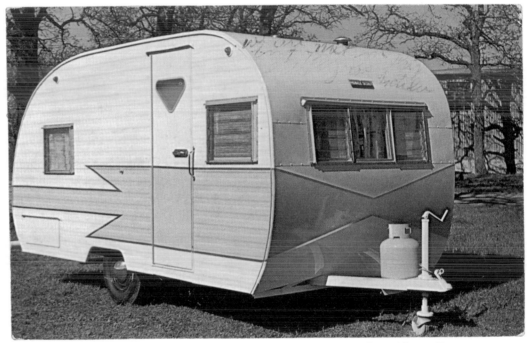

Mobile Scout travels the open road with all the comforts of home. Mobile Scout, Arlington, Texas.

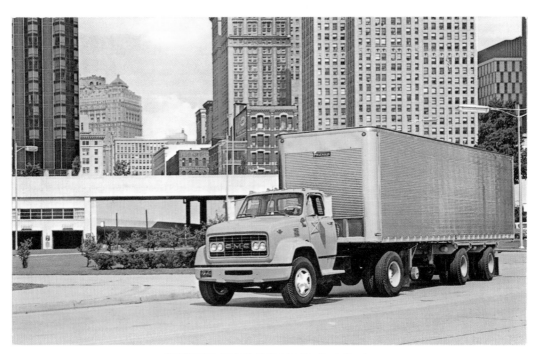

GMC Trucks. Built, Sold, Serviced by Truck People.

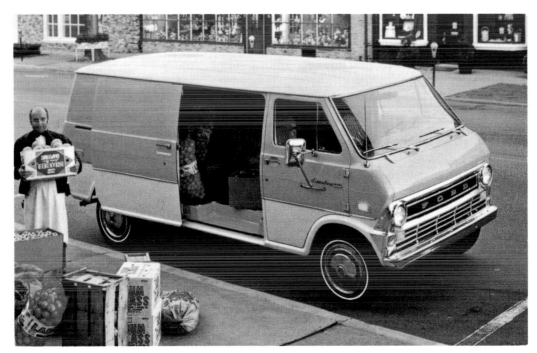

1974 Ford Econoline.

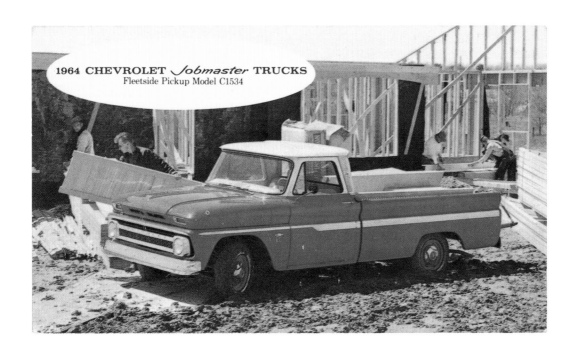

1964 CHEVROLET *Jobmaster* TRUCKS
Fleetside Pickup Model C1534

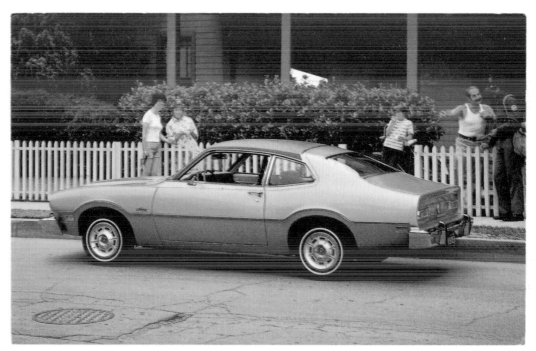

1976 Maverick. 2-Dr Sedan (Exterior Decor Group).

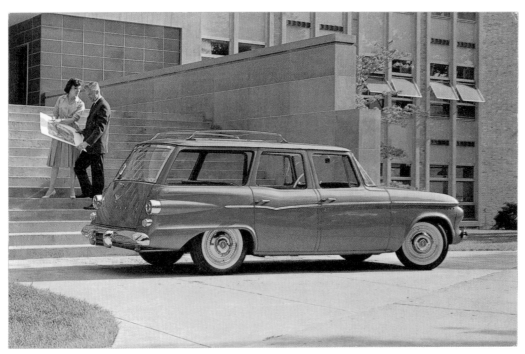

'62 Lark Station Wagon.

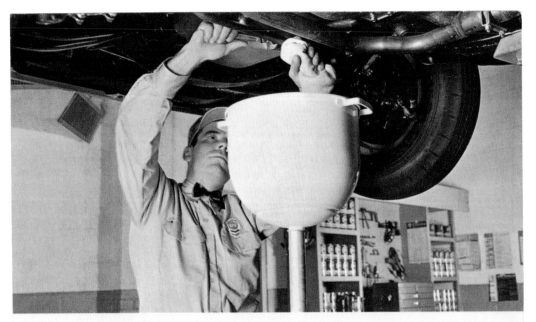

FOR ECONOMY, have your oil drained at recommended intervals.

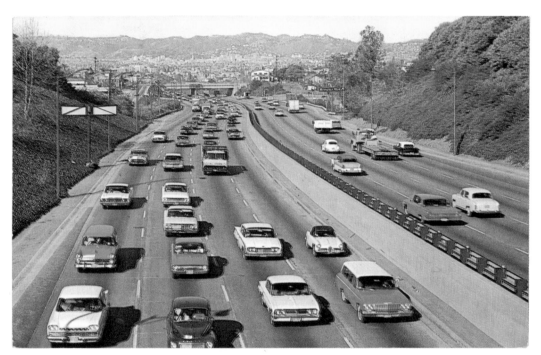

Hollywood Freeway, Los Angeles, California.

COLLECTION MARTIN PARR

MANLEY PRIM PHOTOGRAPHY (FAR HORIZONS TRAILE
MOTEL); MICHAEL HANNAU ENTERPRISES, INC. (INTER
AIRPORT); PENROD/HIAWATHA (PICTURESQUE INDIANA
RICHARDS & SOUTHERN, INC. (AERIAL VIEW OF THE M
I-75, I-85, AND I-20. PHOTOGRAPHY BY J. DOANE); SCH
A. J. SIMONPIETRI (DRIVING SOUTH ON SKYLINE DRIV
15 UNIT AUTO COURT); JACK SWENNINGSON (CRO
& BRIEFING, LIMESTONE AIR FORCE BASE); WALTER B
STUDIO (TOP OF RATON PASS; RATON, GATEWAY TO LA
WHARF, ALL SAINTS STREET, LONDON N1 9PA. PHAIDON F
PHAIDON.COM FIRST PUBLISHED 2000. REPRINTED IN P
PRESS LIMITED. ISBN 978 0 7148 4391 9. A CIP CATALOGU
LIBRARY. ALL RIGHTS RESERVED. NO PART OF THIS PU
SYSTEM OR TRANSMITTED IN ANY FORM OR BY A
RECORDING OR OTHERWISE, WITHOUT THE PRIOR PE